WILMA'S WORLD

This book is dedicated to my mom and dad,
who made sure we *always* had a family dog.

WILMA'S WORLD

GOOD ADVICE FROM A GOOD DOG

BY WILMA THE DOG

CHRONICLE BOOKS

SAN FRANCISCO

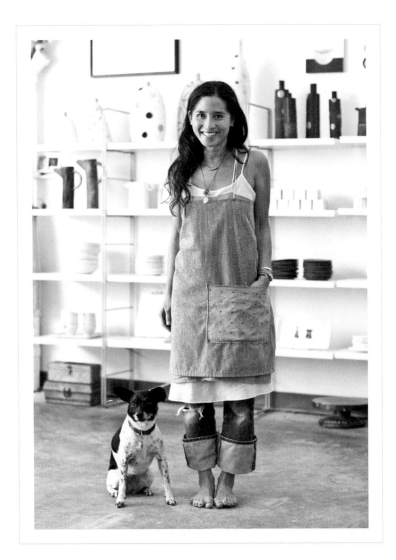

INTRODUCTION

Welcome to Wilma's World, where life is simple and full of joy, and adventure is around every corner.

Wilma has taught me that the beautiful things in life, as in art, happen when you are open to the unexpected. I was originally searching for a brown, rough coat, playful Jack Russell Terrier. But there was Wilma. Black, smooth, and calm. Sitting off to the side by herself, simply observing. Our eyes locked and our fate was set. In that moment, I learned my first lesson from Wilma: Let life surprise you.

Wilma is a perfect co-pilot. Like Wilma, I have never been a big talker, but I have a lot to say. When I first touched clay, I found my voice. When I first photographed Wilma, I found hers. She is subtle, funny, and iconic. Tugging at her leash, pulling me left when I want to go right, she inspires me to stop and notice everything. The simplicity of that, just slowing down, noticing the little things, observing rather than reacting gives me new perspective and makes me feel more connected to the earth.

Wilma has so much wisdom to share, that I couldn't keep it all to myself. So, in Wilma's words:

let the adventures BEGIN!

rae dunn.

rae dunn.

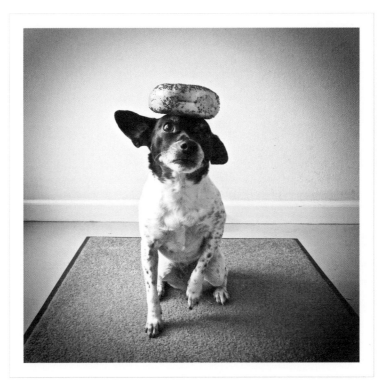

start each day with a well
BALANCED breakfast.

TELL

your

story.

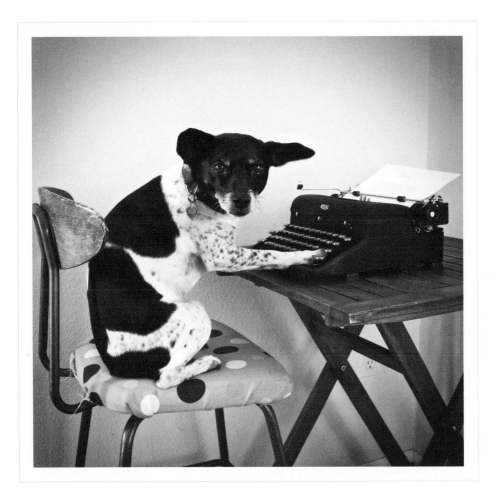

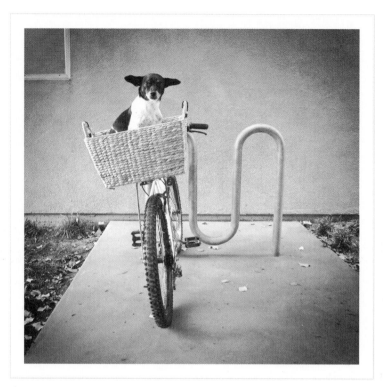

be open to <u>WHEREVER</u> life takes you.

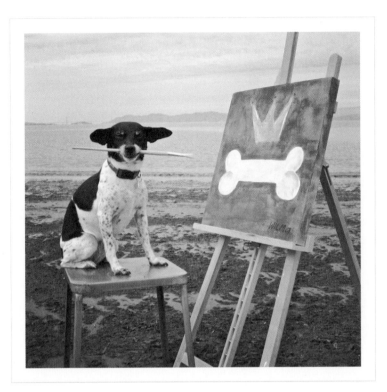

find _INSPIRATION_ in
unexpected places.

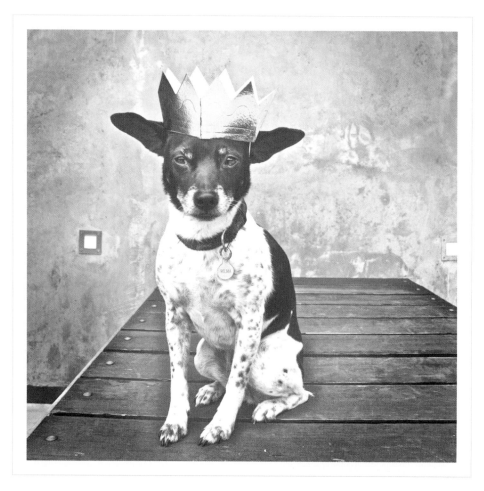

CELEBRATE

every

day.

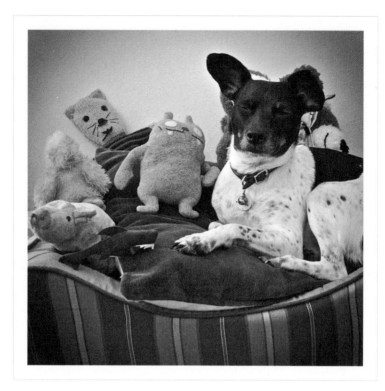

keep good COMPANY.

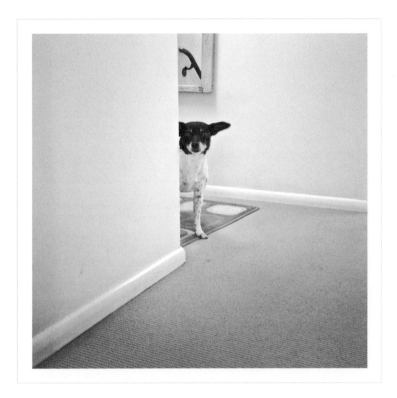

look for <u>OPPORTUNITIES</u>
around every corner.

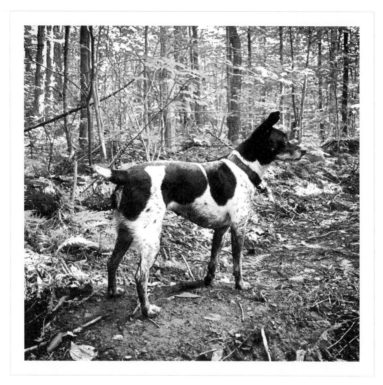

it's <u>OKAY</u> to get your hands dirty.

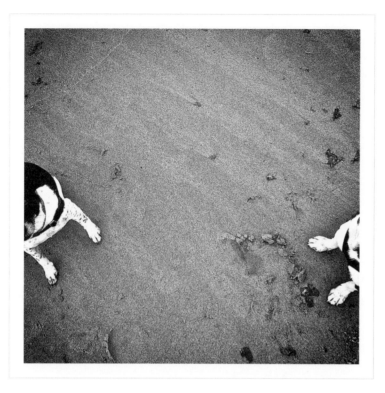

put your _TOES_ in the sand.

take
time
to
REFLECT.

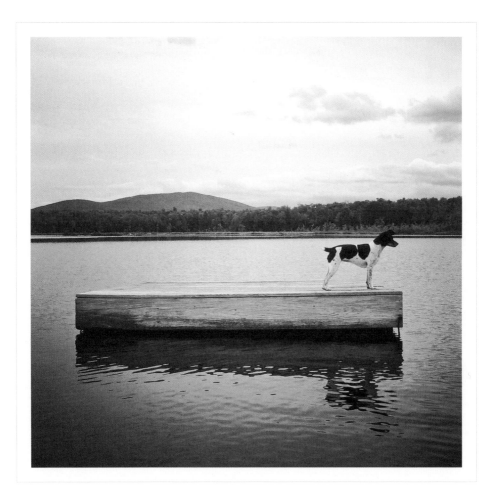

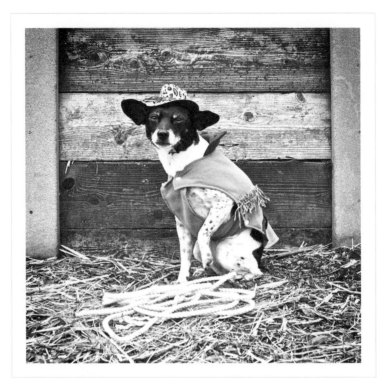

get <u>ROPED</u> into new experiences.

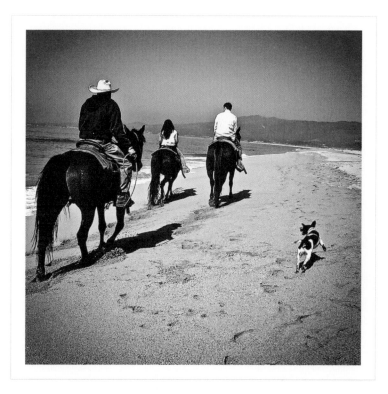

<u>BLAZE</u> new trails.

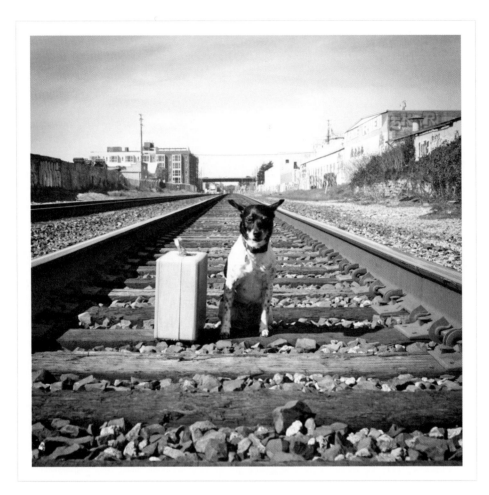

be

SPONTANEOUS.

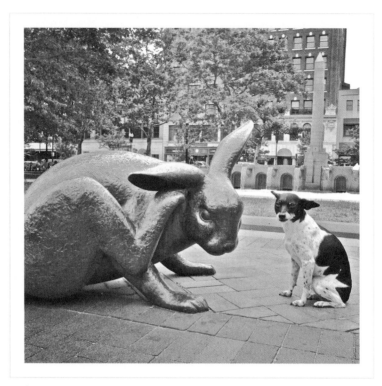

make NEW friends.

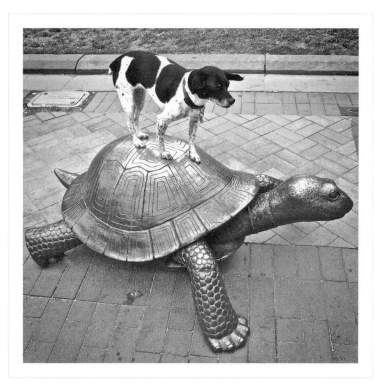

and keep the <u>OLD</u>.

dare to be <u>DIFFERENT.</u>

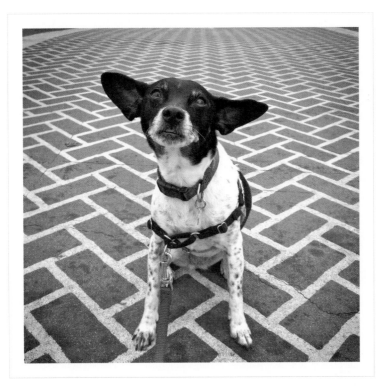

follow your OWN path.

stop

and SMELL

the flowers.

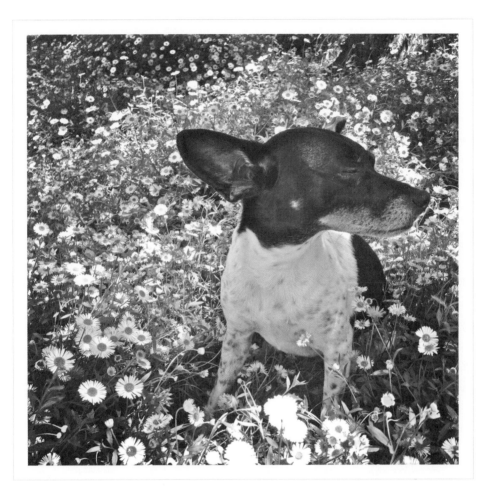

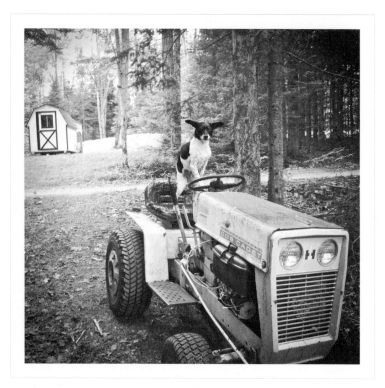

put yourself in the <u>DRIVER'S</u> seat.

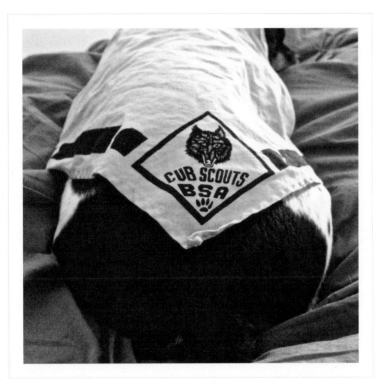

always be PREPARED.

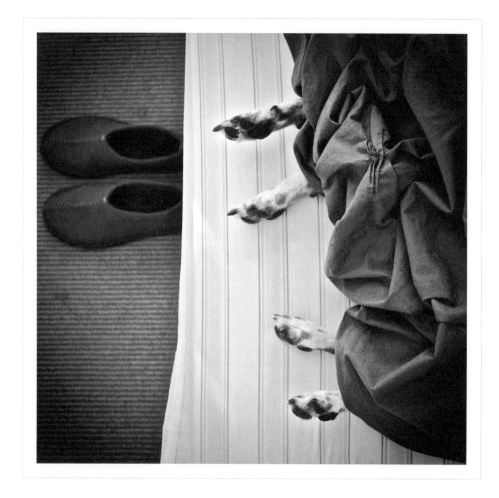

let

SLEEPING

dogs

lie.

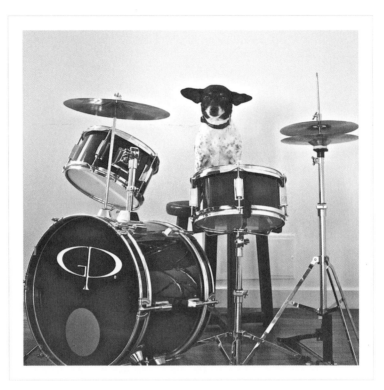

<u>MARCH</u> to the beat of your own drum.

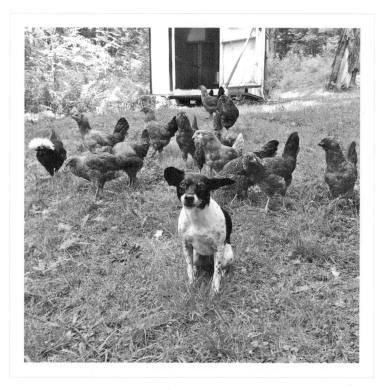

stand _OUT_ from the crowd.

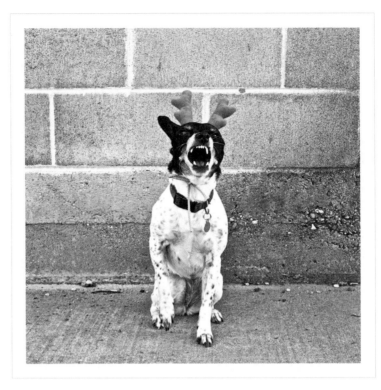

sing your HEART out.

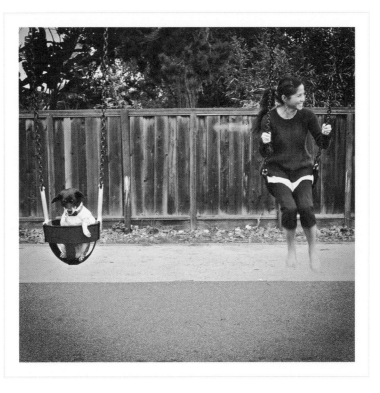

make time to <u>HANG</u> out with your friends.

take

a

VACATION.

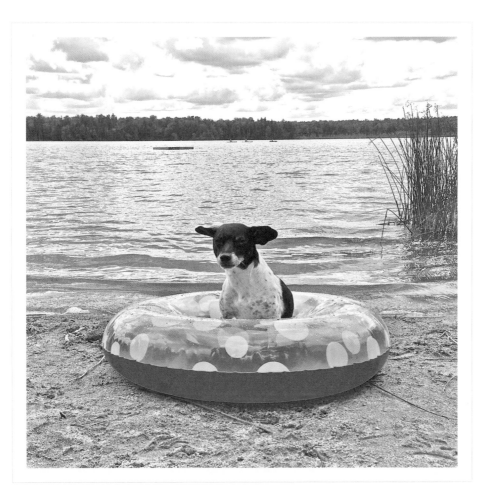

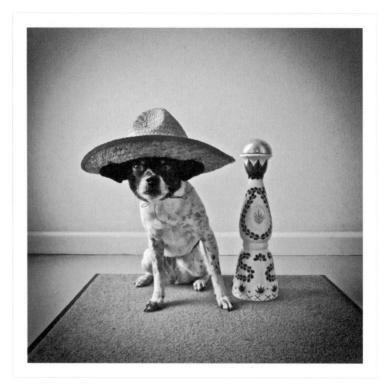

see the WORLD.

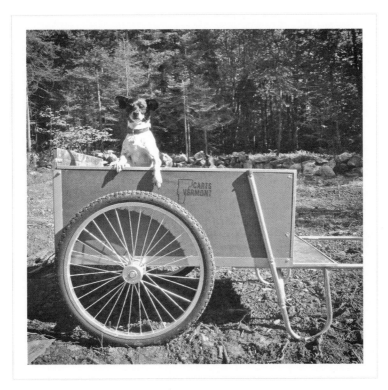

travel in STYLE.

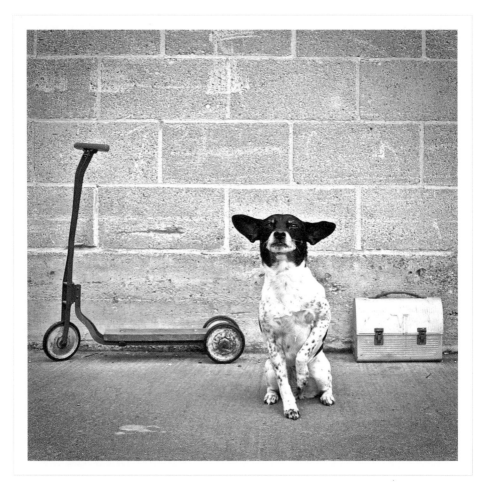

be

READY

for an adventure.

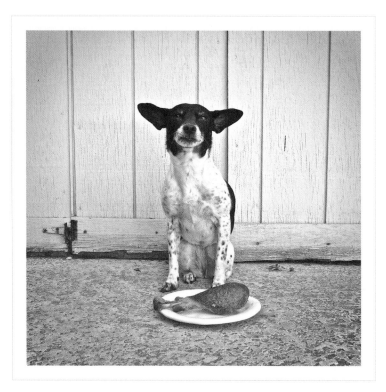

TREAT yourself.

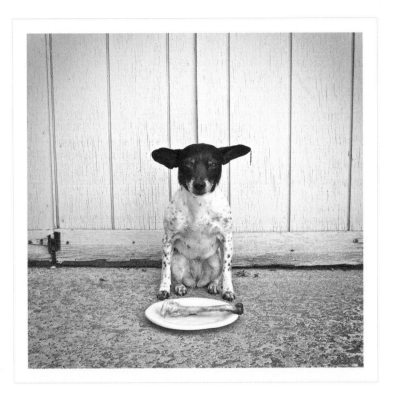

__ENJOY__ every last bit.

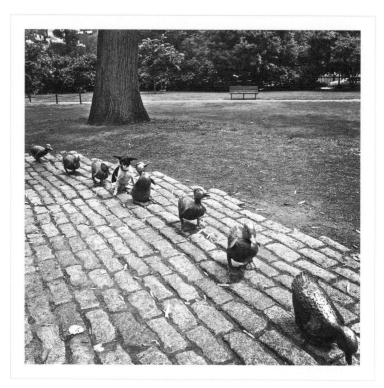

keep your <u>DUCKS</u> in a row.

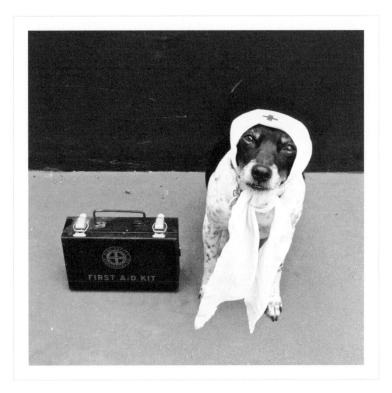

take <u>CARE</u> of others.

make yourself

COMFORTABLE.

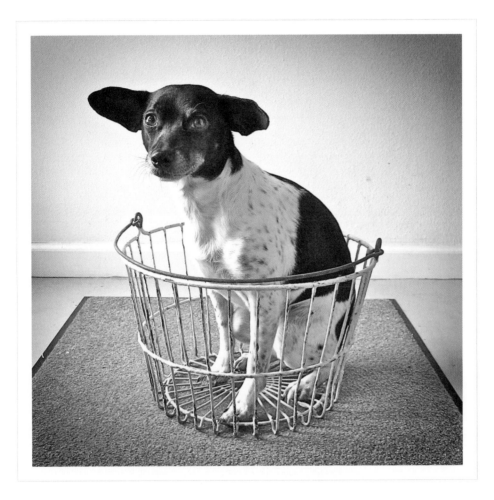

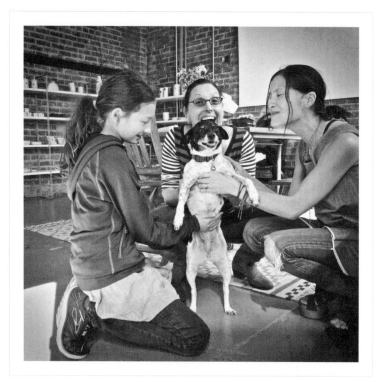

surround yourself with LOVE.

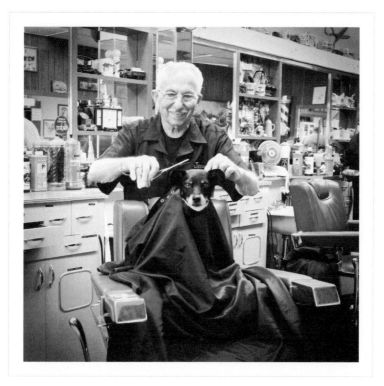

look your BEST.

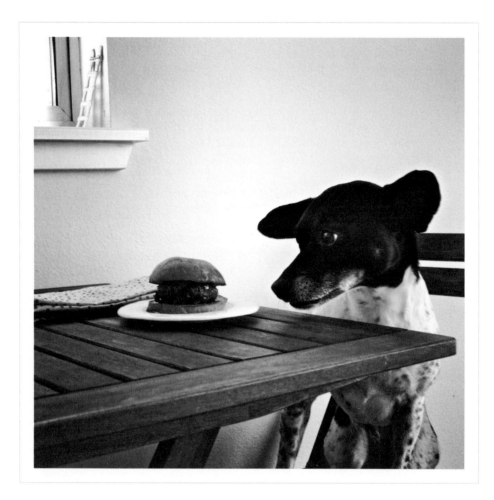

keep your eye

on

the

PRIZE.

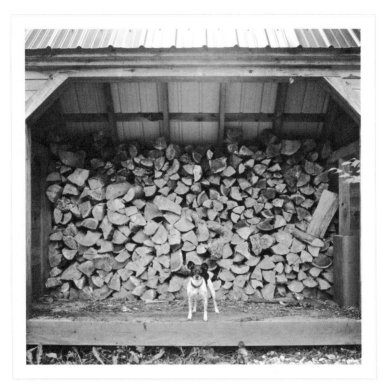

PLAN ahead.

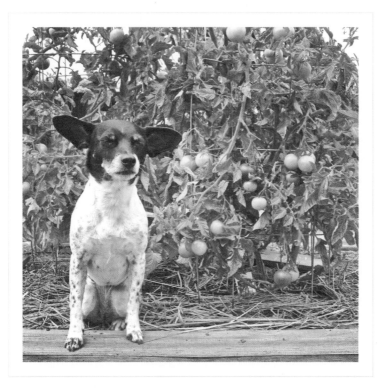

be PATIENT.

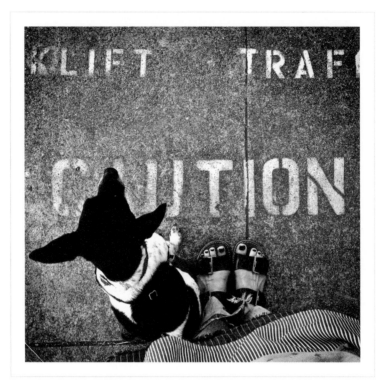

<u>HELP</u> your friends.

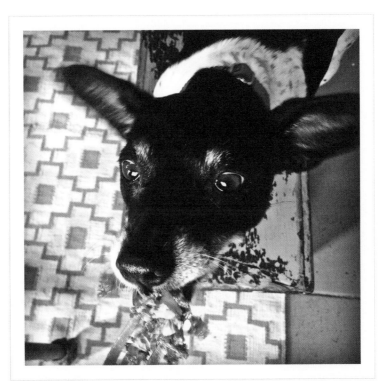

eat HEALTHY

practice makes PERFECT.

practice makes PERFECT.

practice makes PERFECT.

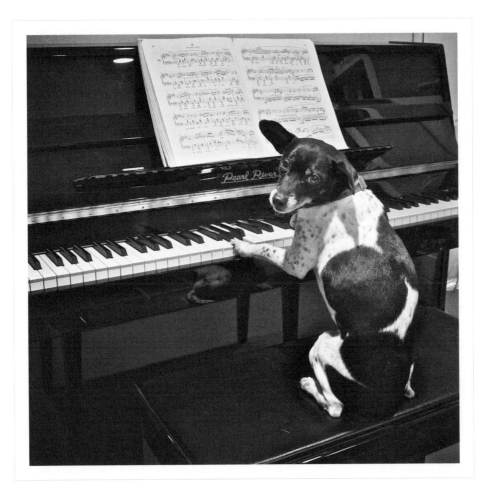

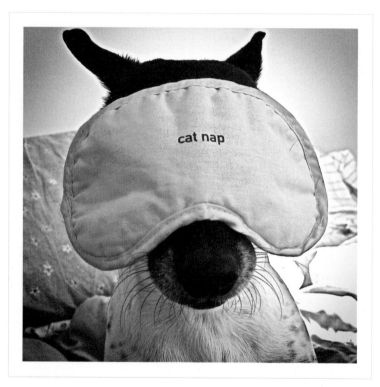

have a sense of HUMOR.

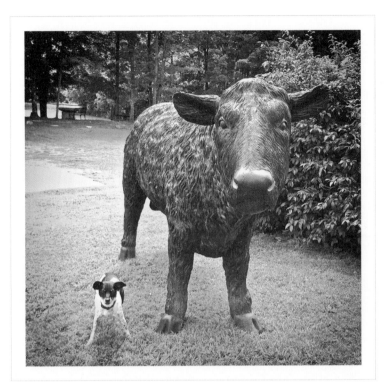

OPPOSITES attract.

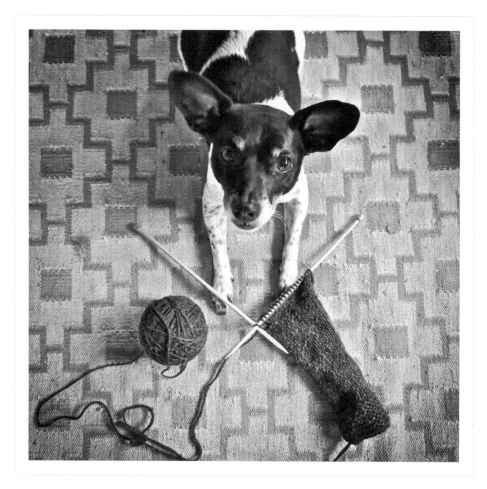

take up

a

new

HOBBY.

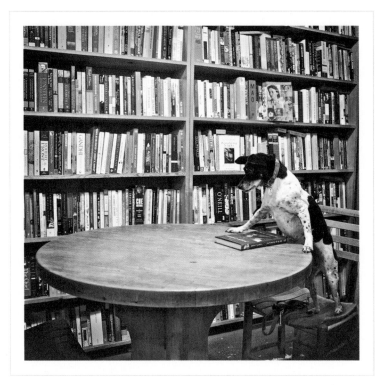

keep LEARNING.

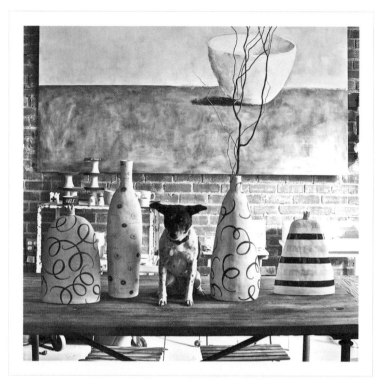

IMMERSE yourself in art.

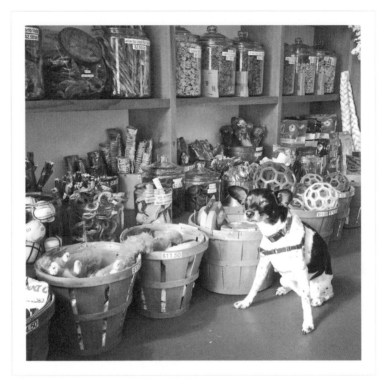

remember: there's never too
much of a GOOD thing.

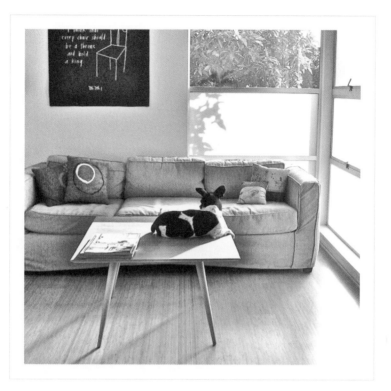

do the UNEXPECTED.

think of

all

the

POSSIBILITIES.

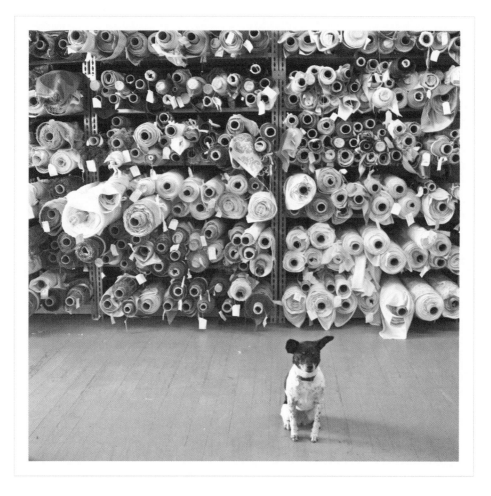

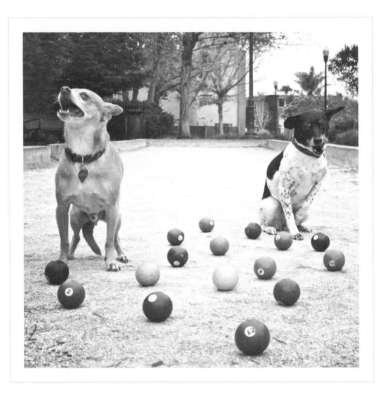

have a _BALL_ with your friends.

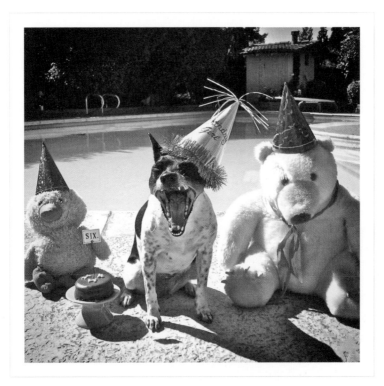

throw yourself a PARTY.

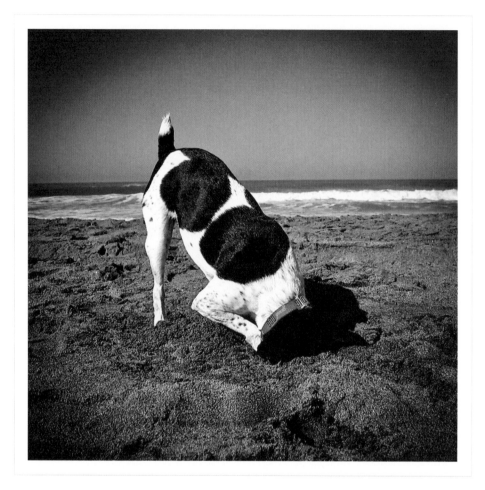

dig

DEEP.

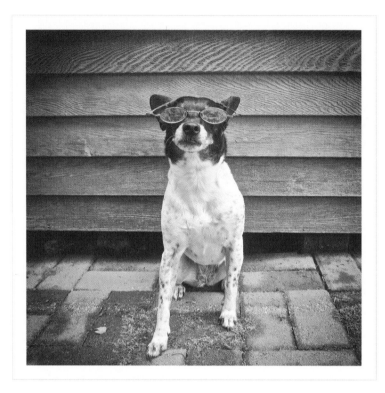

take a CLOSER look.

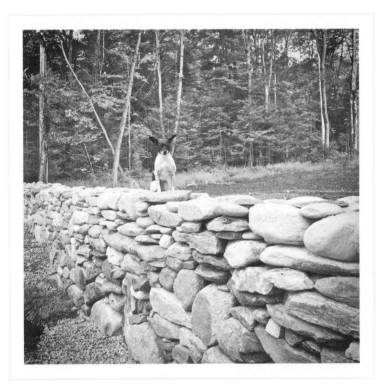

see BOTH sides.

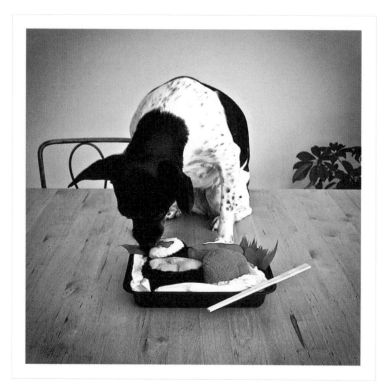

DISCOVER new foods.

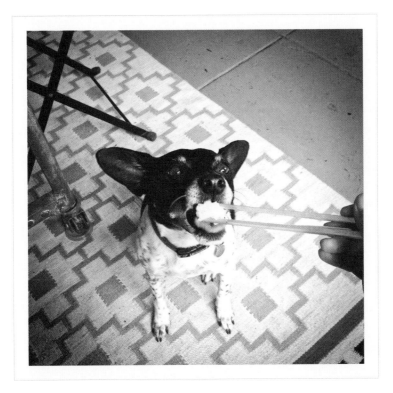

don't <u>BITE</u> the hand that feeds you.

try

WALKING

in someone

else's

shoes.

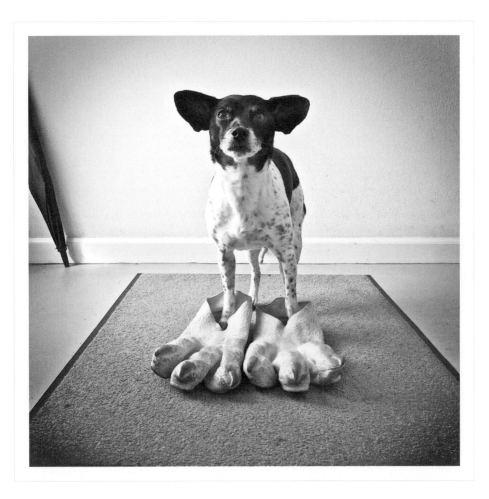

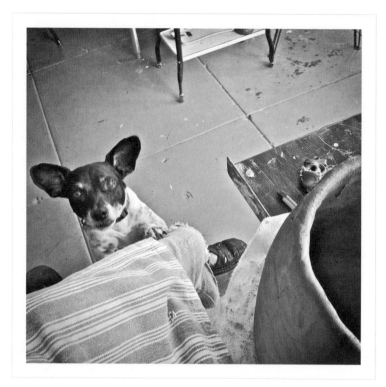

OFFER to help.

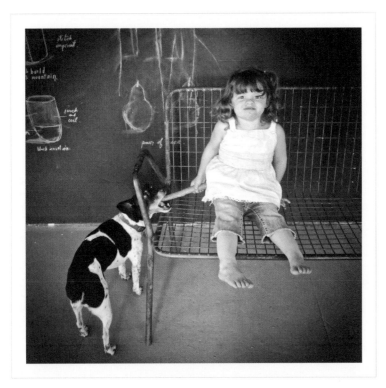

SHARING is caring.

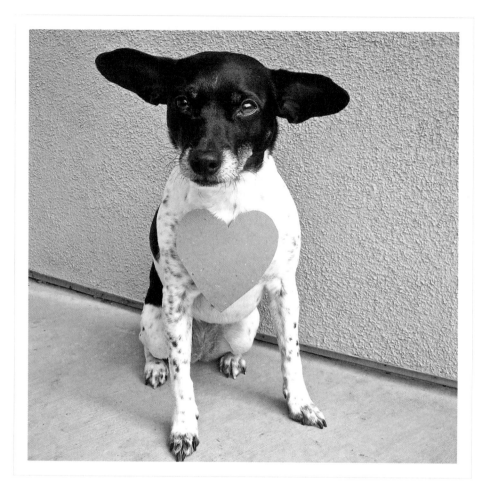

SHOW

your

love.

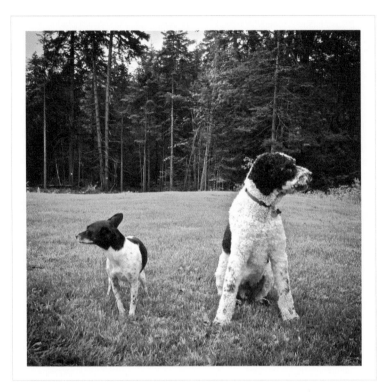

always have your friend's <u>BACK</u>.

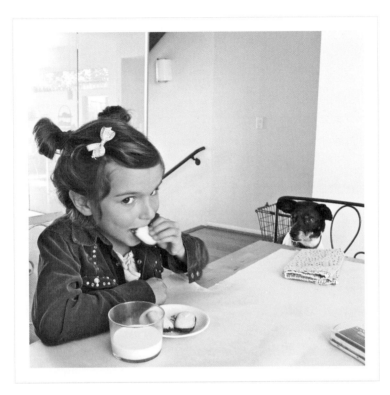

be HAPPY for others.

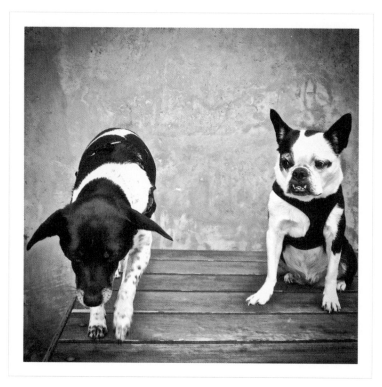

know when it's time to <u>WALK</u> away.

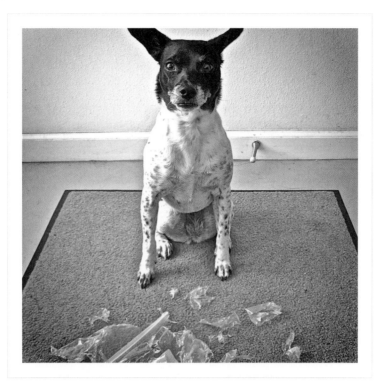

ADMIT when you are wrong.

the grass is green

on

BOTH

sides of the

fence.

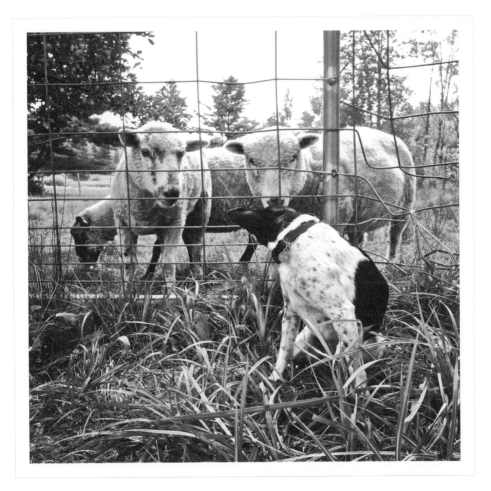

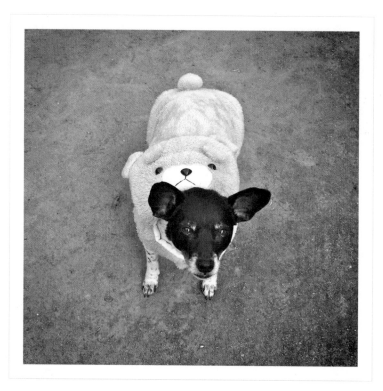

it's what's <u>INSIDE</u> that counts.

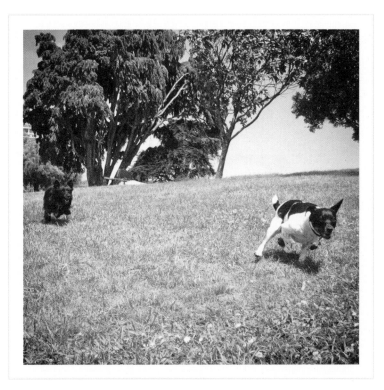

<u>LEAD</u> the way.

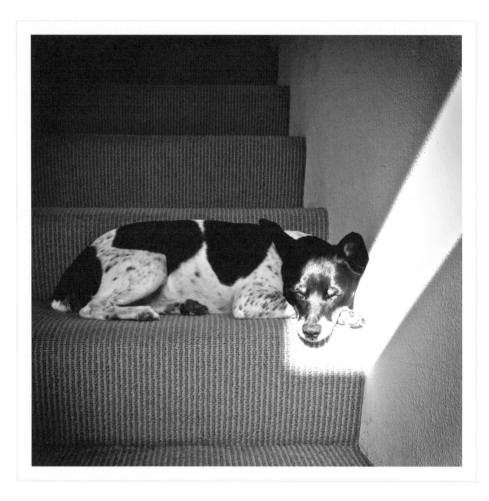

find

your

SWEET

spot.

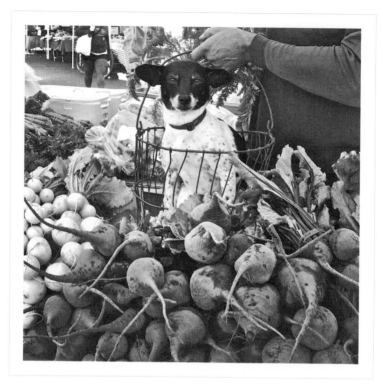

<u>EAT</u> your fruits and vegetables.

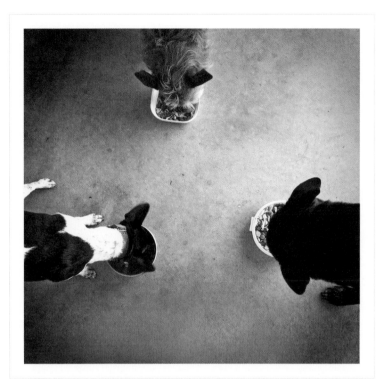

SHARE a meal with friends.

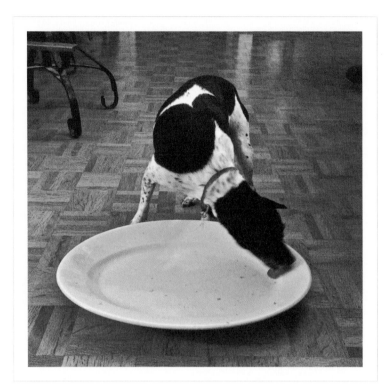

CLEAN your plate.

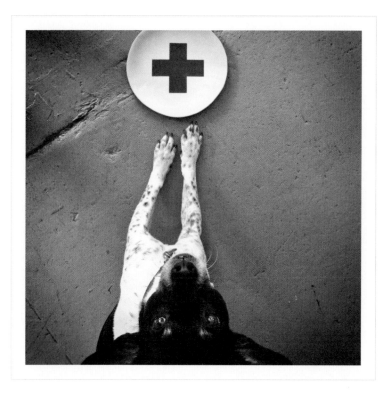

you can always ask for <u>MORE</u>.

get out

and enjoy

the VIEW.

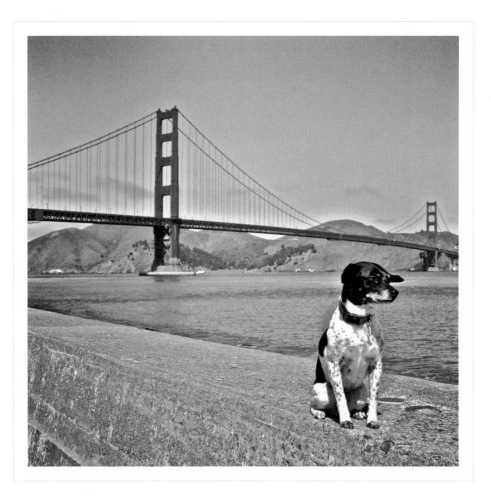

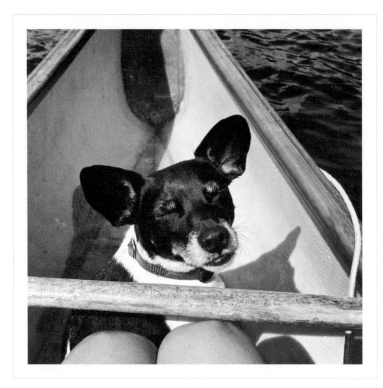

EXPLORE the open water.

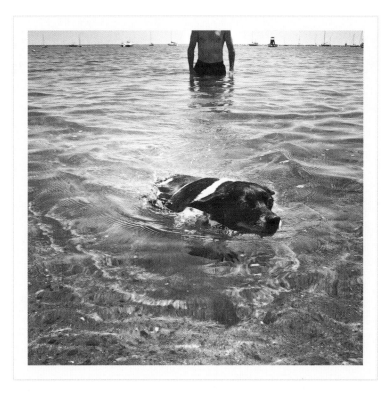

go for a SWIM.

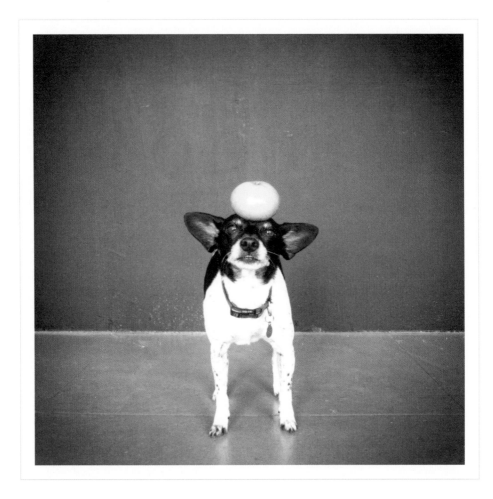

learn

a

neW

TRICK.

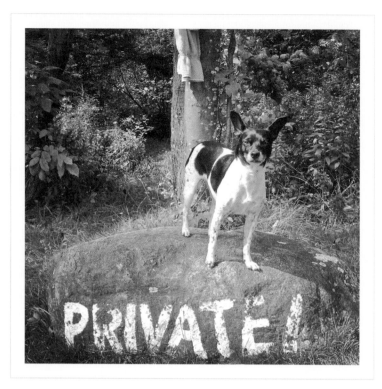

set aside ALONE time.

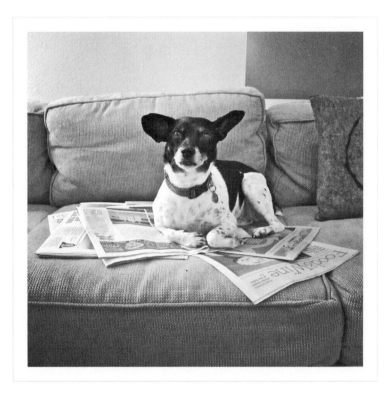

stay on TOP of things.

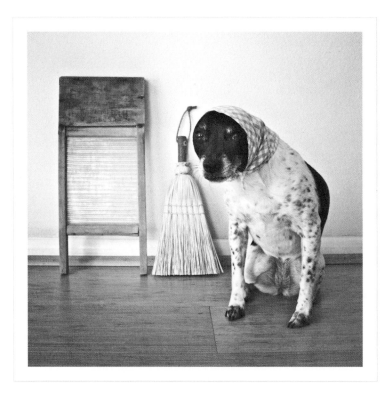

do your CHORES.

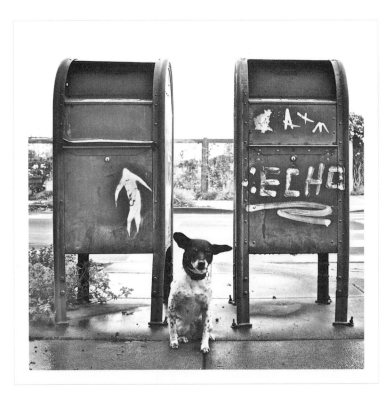

keep in <u>TOUCH</u>.

STRETCH.

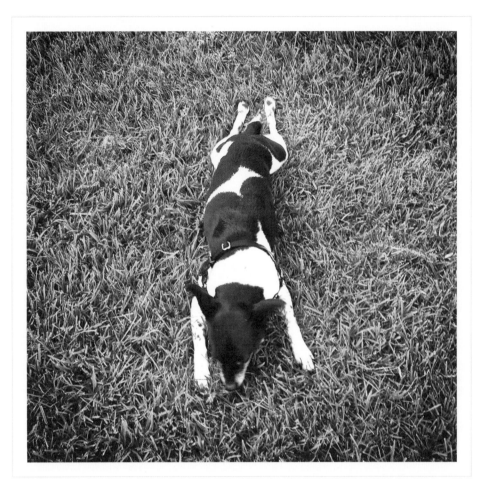

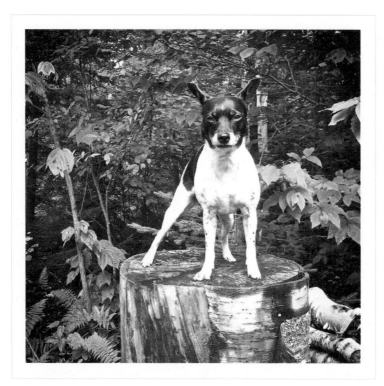

get back to <u>NATURE</u>.

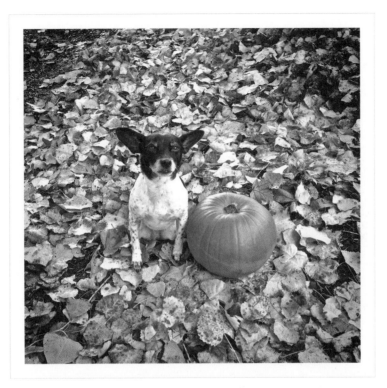

enjoy the SEASONS.

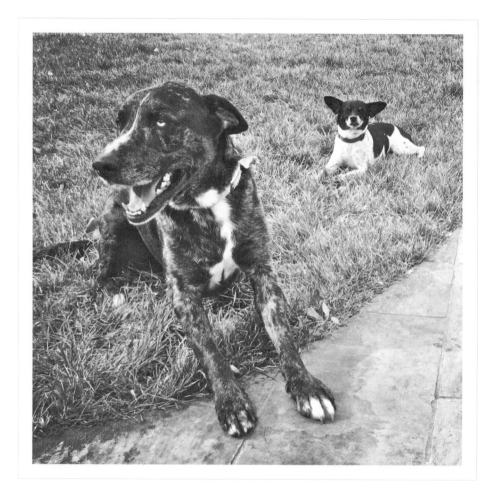

SHARE

the

spotlight.

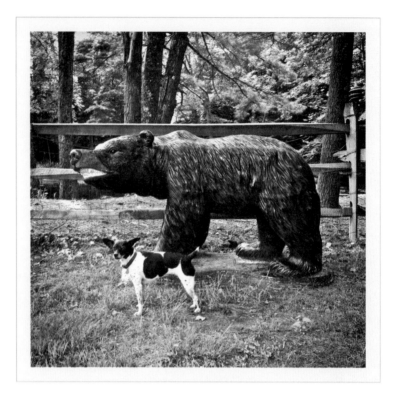

let your friends \underline{STAND} up for you.

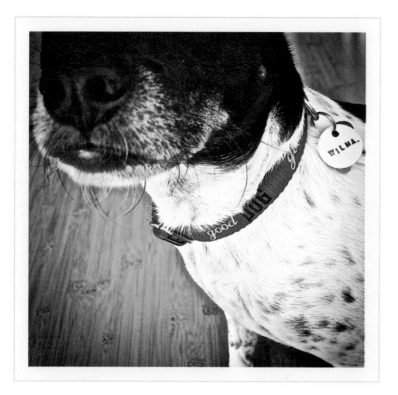

get up <u>CLOSE</u> and personal.

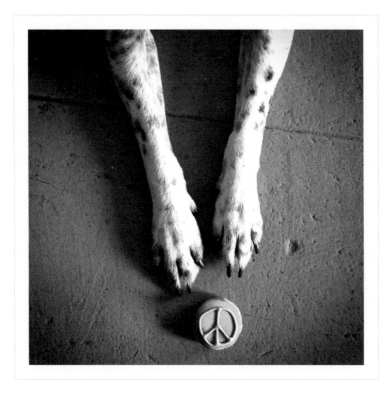

PAUSE for peace.

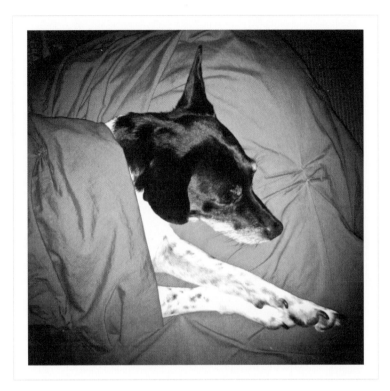

RECHARGE.

enjoy a

DOG

day

afternoon.

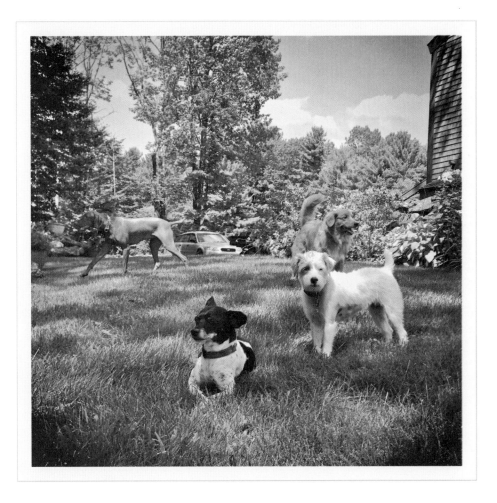

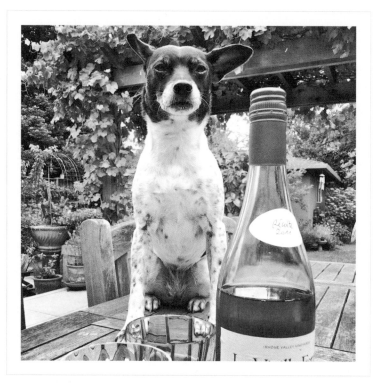

appreciate the _FINER_ things in life.

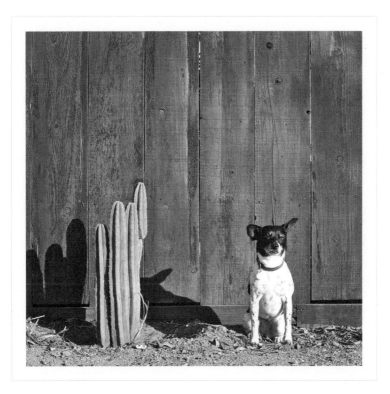

SOAK up the sun.

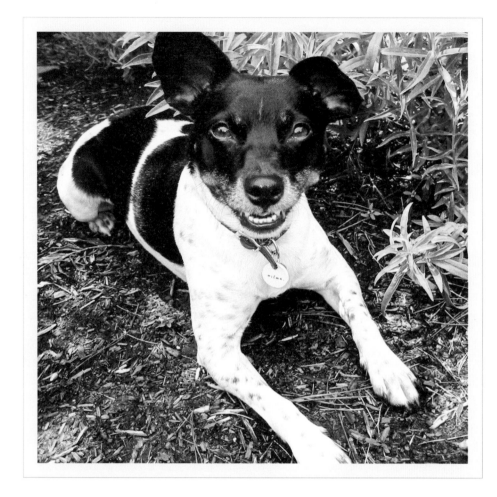

SMILE

and the whole world

SMILES

with you.

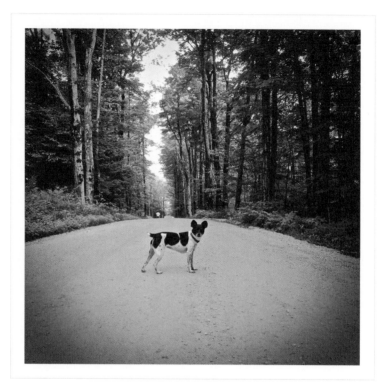

go for a long <u>WALK</u>.

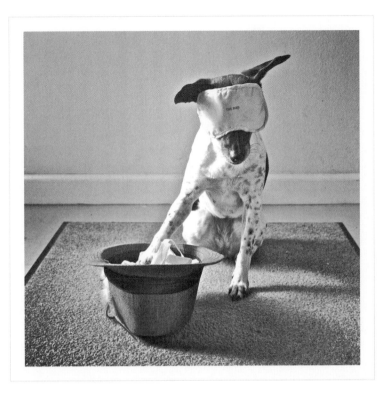

let life _SURPRISE_ you.

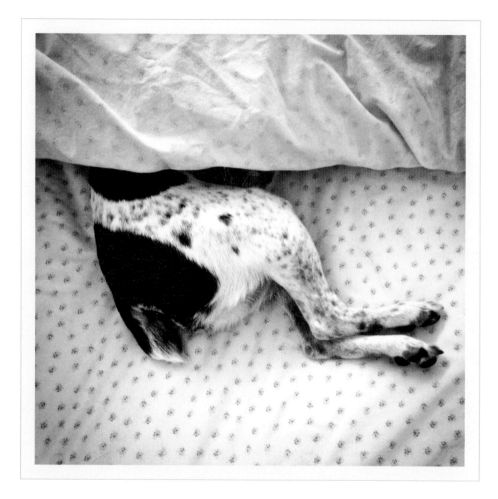

WILMA is a Jack Russell Terrier who enjoys sleeping 'til noon and running in figure eight patterns. She loves all foods except fake hot dogs and egg yolks. She's a real people person.

RAE DUNN is an artist living in the San Francisco Bay Area with her husband and Wilma. Her work is sold worldwide. Rae and Wilma can usually be found in their shared studio in Berkeley (when they are not out exploring the world).

(people and places we would like to thank)
Johnny Wow (for being in our world), Debra Lande (for believing in our world), Dan Goodman (for leading me to Wilma), Corrie Dunn, Rick Jow, Jackie Swoiskin, Mark Swoiskin, Chloe Swoiskin, Jessica Williams, Katharine Glenchur, Lisa Congdon, Kathleen Divney, Christa Assad, Rebecca Bazell, Tamar Hurwitz, Kevin Wickham, Don McPherson, Deb Fink, Tom + Judy Wagner, Polly Wagner, Wm. Levine, Sara Paloma, Thomas Story, Clara Story, Mary Mar Keenan, Bo Carper, Maysa Jane Carper, Anmy Leuthold, Christine Eisner, Stephen Lefkovits, Jared Lashkinsky, Jerry Sandlin, Don Frazier, Lesley Madison, Dot's Camp, GEORGE Pet Shop, the Grand Barber Shop, Riverdog Farm, Discount Fabrics, Lotti, Felix, Wilfredo, Keesha, Lula, Blue, Nutmeg, Ginger, Petunia.

Liberty of Congress Cataloging-in-Publication data available.

ISBN 978-1-4521-4022-3

Manufactured in China

MIX
Paper from
responsible sources
FSC® C008047
www.fsc.org

Design by Nami Kurita

10 9 8 7 6 5 4 3 2 1

Chronicle Books LLC
680 Second Street
San Francisco, CA 94107
www.chroniclebooks.com